Christmas '94
We've both enjoyed this book
a lot. Had a lot of laughs.
Hope you will too!
Love, Dad
& Janne

>MAN'S BEST FRIEND<

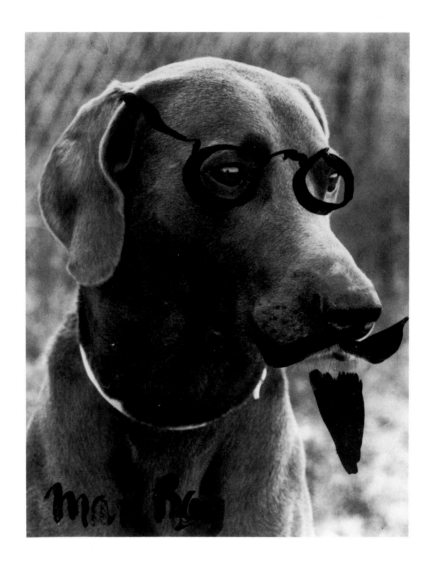

MAN RAY
1979. INK ON PHOTOGRAPH, 13 X 10½".
COURTESY HOLLY SOLOMON GALLERY, NEW YORK

PHOTOGRAPHS AND DRAWINGS BY
WILLIAM WEGMAN

INTRODUCTION BY LAURANCE WIEDER

MAN'S BEST FRIEND

HARRY N. ABRAMS, INC., PUBLISHERS, NEW YORK

ACKNOWLEDGMENTS

Betsy Connors
Anita Grossman
Robert Kushner
Hester Laddey
Holly and Horace Solomon
Elly and George Wegman
Gayle Wegman
Laurie Jewell Wegman

FROM POLAROID
Rogier Gregoire
John Reuter
Stanley Rowin
Joanne Verburg

FRONT COVER
ELEPHANT
1981. COURTESY FRAENKEL GALLERY, SAN FRANCISCO

BACK COVER
SILVER PORTRAIT (right panel of triptych)
1982. COURTESY HOLLY SOLOMON GALLERY, NEW YORK

Editor: Eric Himmel
Designer: Tina Davis

Library of Congress Cataloging in Publication Data

Wegman, William.
Man's best friend.

1. Photography of dogs. I. Wieder, Laurance,
1946– II. Title.
TR729.D6 W43 779'.32 82-4031
ISBN 0-8109-2266-5 AACR2

Photographs © 1982 William Wegman
Introduction © 1982 Laurance Wieder
Published in 1982 by Harry N. Abrams, Incorporated, New York

Printed and bound in Japan

FOR MAN RAY
(1890–1976)
(1970–1982)

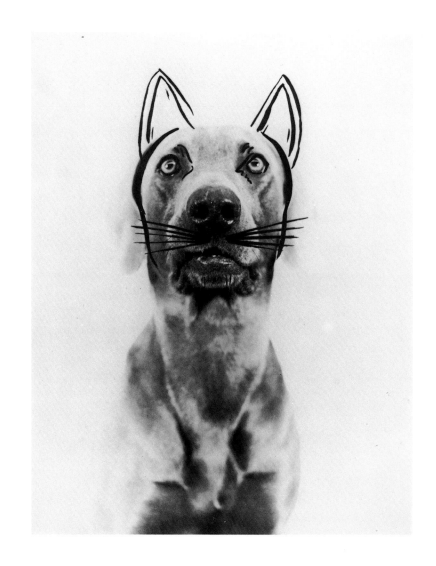

RAY CAT
1979. INK ON PHOTOGRAPH, 20 X 16".
COURTESY HOLLY SOLOMON GALLERY, NEW YORK

William Wegman's collaboration with Man Ray began in 1970 in Long Beach, California. Wegman had just moved there from Wisconsin to teach painting and drawing at the university, and he finally gave in to his wife's long-standing request that they get a dog. An advertisement—"Weimaraner puppies, $35"—appeared in the local paper. There were six females and one male in the litter; Wegman liked the male. Not completely convinced, he decided to flip a coin: heads, no dog; tails, that dog. It came up tails—seven times. Wegman brought the six-week-old puppy home.

Originally, Wegman wanted to name his weimaraner "Bauhaus," after the famous art school founded in Weimar, Germany, in 1919. But the puppy shivering in the corner of the studio didn't look like a Bauhaus. A Bauhaus, Wegman thought, should be black, white, and square, while this dog was gray shaded toward blue, and plump with baby fat. "Suddenly, late that night," he recalls, "it came to me like a light bulb: Man Ray."

Wegman works in three mediums: drawing, video, and (as he says) "photography, through the back door." His witty drawings propose conundrums, little grotesqueries, wry expressions sometimes embellished with written captions or comments. His video works, often reminiscent of vaudeville blackout numbers, play out a single idea in real time. In his altered photographs, where he draws or paints over black-and-white photographic prints, he paints what he cannot photograph. In these Wegman stands the artist Man Ray on his head, for the Surrealist claimed he only photographed what he could not paint. Naming the dog Man Ray was not necessarily meant, at first, as an *hommage*.

From the beginning, Wegman incorporated Man Ray into his work. He kept the dog with him all the time, at classes and in the studio. Man Ray, for his part, would not stay out of the artist's way. When Wegman tried tying the dog in a corner of the studio, Man Ray howled. Unleashed, he would blunder onto the set where Wegman was arranging things for the video camera. It became much easier for Wegman to work with the dog than around him. Their first videotape together featured Man Ray gnawing on a microphone (page 8). Black-and-white portraits of the dog served as the basis for altered photographs. Wegman added pointed ears and whiskers to Ray's face to turn him into *Ray Cat* (page 6). Drawing on a

REEL 1
1970–72. VIDEOTAPE.
COURTESY CASTELLI-SONNABEND TAPES
AND FILMS, NEW YORK

beard and spectacles, Wegman presented the dog as an artist, *Man Ray* (frontispiece).

Man Ray became skilled as a model, having begun at an early age. He has an enormous need for love and attention, and is willing to put up with any number of transient irritations for the sake of love. Wegman recalls two periods, in 1977 and again in 1978, when he worked on his own, drawing, usually in the darkroom with the light on. "Ray sulked around the house. Now and then he would stalk into the darkroom, glare at me for a minute, then turn around and walk out."

Until the middle 1970s, Wegman photographed Man Ray in a variety of situations that displayed the dog's elegant shape from every angle. But as Man Ray aged, he grew heavy, and the artist began draping his subject to hide his thickening figure. "I hated to see him get older," Wegman explains. "That's a real problem in using one subject over so many years." A shy man, Wegman likes to stare at Ray with what he describes as a mixture of love and detachment. "To stare that way at a person would be too embarrassing." Dressing and disguising the dog, done first out of tact, became itself a fascination, and the artist "would have felt funny asking a person to put all those things on." A human model would not have the dog's stamina, patience, verve, or seriousness.

In the summer of 1978, Wegman was invited by the Polaroid Corporation to use its large-format camera in Cambridge, Massachusetts. One of a number of artists and photographers to receive such an invitation, Wegman "reluctantly" accepted, and soon began to make regular visits to the Polaroid studio. The camera, which works on the same principle as the familiar Polaroid camera invented by Dr. Edwin Land in 1947, makes 20-x-24-inch instant color prints on Polacolor professional film. It is operated by a technician, often assisted by a film handler and a lighting specialist. The studio supplies a set with a seamless-paper backdrop whose physical limitations eliminate distractions. When Wegman is on location, the technicians accompany the camera. Paced by the 85-second developing time of an image, Wegman can make changes in each pose until he gets a picture that satisfies him: about one in every twenty exposures. "The pictures come out like presents. And usually I thank everybody—the studio crew, Dr. Land, Ray—when the day is over."

These photographs evidence the same wit and concerns as the drawings and altered photographs, but as "through-the-back-door" photography, they are more immediately related to Wegman's videotapes. In single photographs, Wegman and Man Ray manage to condense the extended conceits of the video performance into one elegantly composed and articulate image. Diptychs and triptychs tell spare stories. Wegman's fascination with the way things can be changed, explicit in the altered photographs, here takes an even more direct form. Costumes and props, often purchased in a local dime store the day before a shooting, afford one kind of metamorphosis: a bit of tinsel turns a weimaraner into an airedale in *Airedale* (plate 21). *Ray Bat* (plate 11), even more economical in its means, is simply a photograph of Man Ray lying on his back, with a lamp and flowers suspended upside down from the studio ceiling in a corner of the frame. Wegman analogizes the instant camera to video playback, which allows the artist to see immediately the work he has done. But unlike the grainy video image, the resulting glossy color prints have the presence and uniqueness of paintings: paint by camera, not by hand.

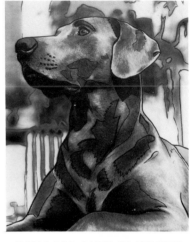

NOBLE DOG—PAINT BY NUMBERS
1978. INK ON PHOTOGRAPH, 12 ½ X 10".
COURTESY HOLLY SOLOMON GALLERY,
NEW YORK

Poses for individual pictures are blocked out in sketches Wegman brings to the studio or are improvised on the set from what the dog suggests, what he can do, what Wegman can get him to do with coaxing and practice. Over the years, Ray and Wegman have developed a vocabulary, words and phrases that elicit particular responses. "Who's here?," for example, will cause Ray to look alertly toward the nearest door: Wegman used this question to make the right panel of *Garden* (plate 22). Sometimes a combination of phrases is needed. In *Broken/Hurt* (plate 6), Wegman said to Ray, "Give me your paw. Bad dog." Then he snapped the shutter. Sometimes the expression is the dog's response to his predicament: *Baby Magic* (plate 23) is probably Ray's last word on child rearing. When Wegman asked artist Robert Kushner to design a fancy leash for Ray, Kushner got carried away and made seven outfits. The dog made repeated visits to Kushner's studio for fittings. The result was the *Suit/Suite* (plate 5). The dog liked some of his costumes better than others, and perhaps it shows. He was particularly delighted with his pantaloons, cap, and garter in *French III*; he resented *Bag Lady*.

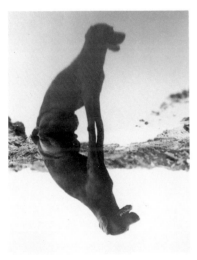

MAN RAY WITH REFLECTION
1978. PHOTOGRAPH, 21¼ X 19".
COURTESY HOLLY SOLOMON GALLERY,
NEW YORK

Although holding a pose is hard work, weimaraners are a working breed, and Ray acts a little lost if he hasn't been on

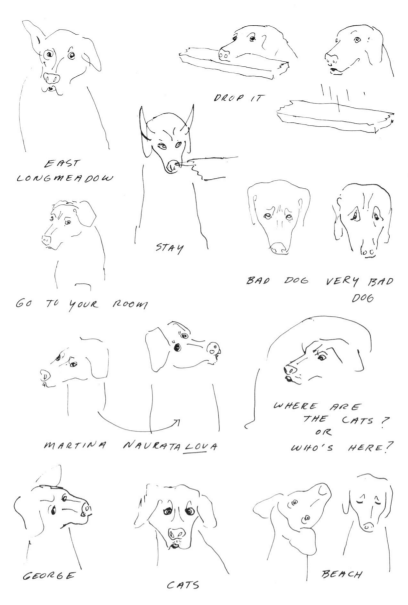

EAST
LONGMEADOW

DROP IT

STAY

GO TO YOUR ROOM

BAD DOG VERY BAD
DOG

MARTINA NAVRATA*LOVA*

WHERE ARE
THE CATS?
OR
WHO'S HERE?

GEORGE

CATS

BEACH

camera for a while. Standing for the shot—holding on point—
is, after all, in his blood. As for dressing up, Man Ray likes
being covered or wrapped (as a puppy, he happily allowed
Wegman to drape him in a cape, but ran away whenever he
saw the leash). He doesn't mind being sprinkled, as he was
with flour for *Dusted* (plate 24); doesn't like but tolerates the
noise of Disco Dazzle hair spray, used, for example, in *Silver
Portrait* (back cover).

Does Man Ray understand his place in art? Or perhaps, more
plausibly, does he understand that works of art exist, and that
he has an image? He is careful about stepping on paper on the
floor. He doesn't recognize himself in photographs, but he
does wag his tail at his image in the mirror, and he cocks his
head at the audio part of a video playback. Man Ray does not
like replicas of animals, and once crossed the street to avoid
a rocking horse. While Wegman developed his black-and-white

pictures of Man Ray, the dog slept under the table that held the developer trays.

Man Ray has appeared on the covers of three serious art magazines—*Avalanche*, *Artforum*, and *Camera Arts*—as well as on the cover of a Sotheby's auction catalogue. Johnny Carson played Wegman's videotapes on the "Tonight" show, and the dog has appeared both on tape and in person on Public Television, "Saturday Night Live," "Tomorrow," and David Letterman's "Late Night" show. His status as an art world celebrity doesn't affect Ray, who like any other dog goes for walks, eats dog food, plays with his favorite rocks and teddy bears in the living room, and sleeps on the couch with the television on. Wegman, however, must contend with people on the street who recognize the dog rather than the master, and with the disproportionate attention paid to his Polaroid portraits of Man Ray, at the expense of his drawings and non-canine video projects. On the other hand, with Man Ray as constant companion, the artist always has a built-in distraction in conversations, a social exit. The dog's fame is the man's liberation.

Many of the dog's admirers harbor the same proprietary feelings and jealous concern other people have toward beloved, public, human figures. While the celebrity weimaraner may just be one more weird wrinkle in the fabric of American publicity, the sense that he comes to be known through the pictures, that uncanny relationships are revealed, places the model and his portraits among the objects of art.

To those unfamiliar with the photographs of Man Ray, the dog's most cunning disguise is to be himself. One winter afternoon at around five o'clock, William Wegman took Man Ray out for a walk in New York's financial district, where their loft is located. While Wegman stood around pretending Ray was not his dog, Ray sniffed the trash piles and curbs of Greenwich Street and conducted his business. A group of brokers headed home from Wall Street stopped to watch and discuss: What kind of dog was this? Was it a retriever, was it a weimaraner? They debated for a few moments until the light failed, concluded, "It's just a gray dog," and continued home.

Laurance Wieder
New York City
March, 1982

YARN (CHARDIN)
1981. COLLECTION STEVEN BAKER

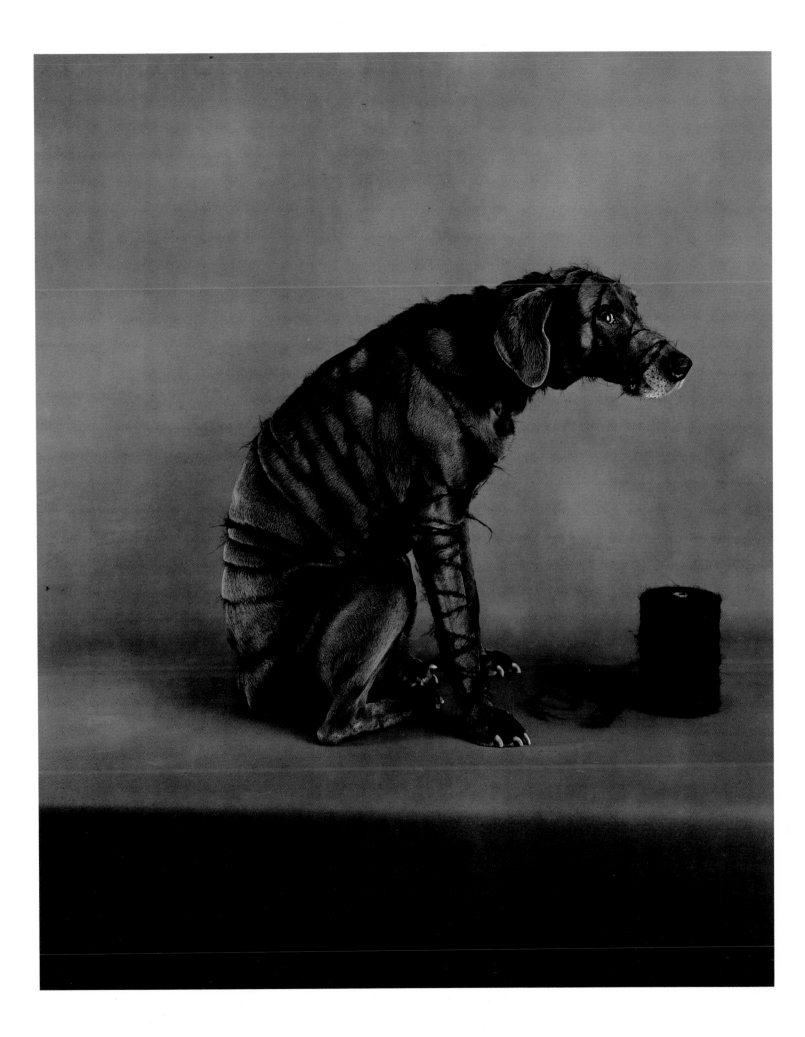

FLORA AND FAUNA
1981. COURTESY DART GALLERY, CHICAGO, AND HOLLY SOLOMON GALLERY, NEW YORK

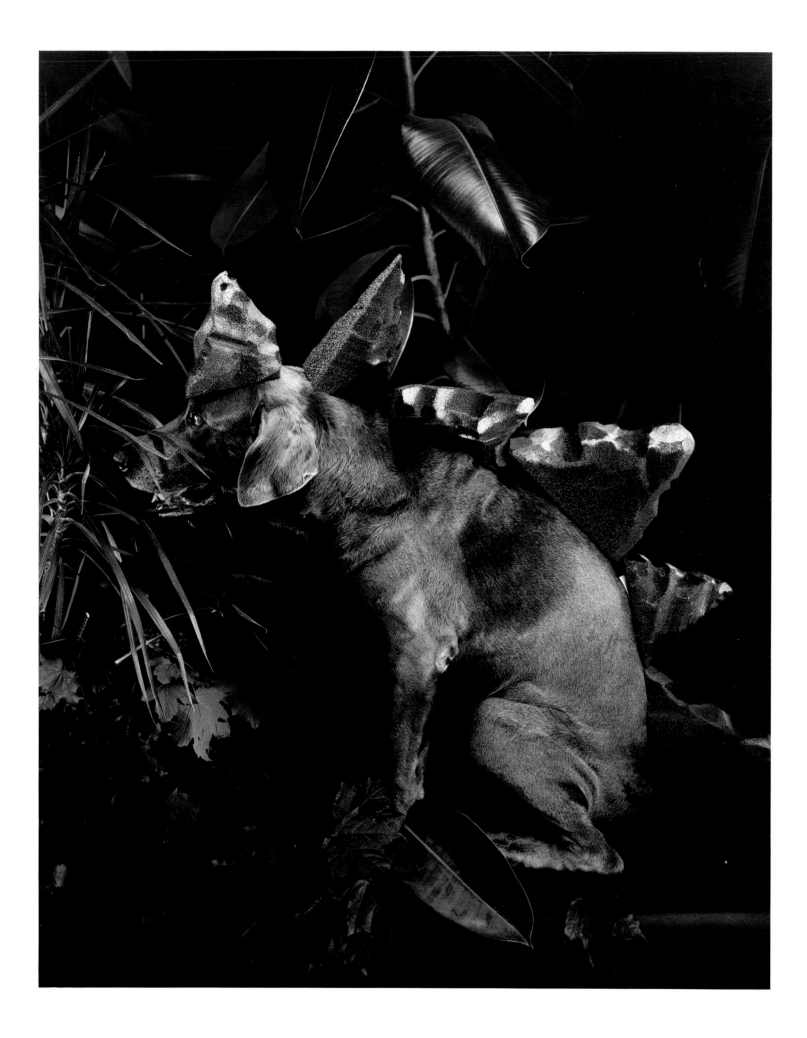

BLANKET
1981. COURTESY HOLLY SOLOMON GALLERY, NEW YORK

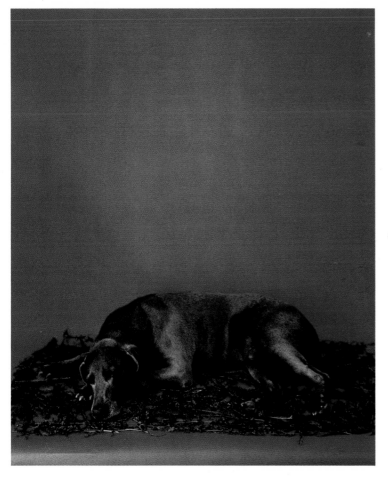 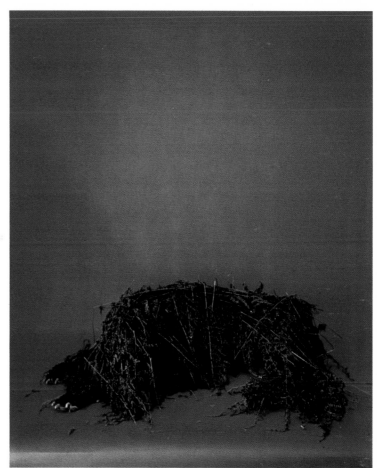

TALL DOG
1982. COURTESY HOLLY SOLOMON GALLERY, NEW YORK

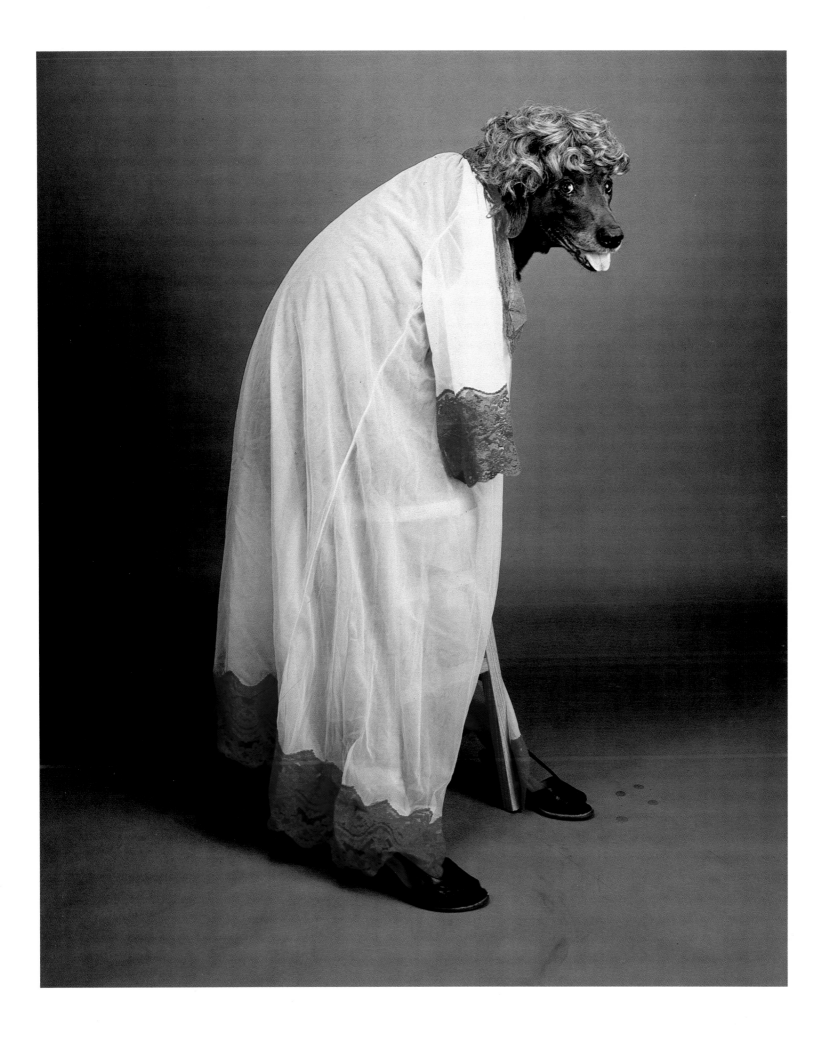

5
SUIT/SUITE
1979. COSTUMES DESIGNED BY ROBERT KUSHNER

LOUIS XIV
COLLECTION ELLEN SALTONSTALL AND ROBERT KUSHNER

BAG LADY
COLLECTION ELLEN SALTONSTALL AND ROBERT KUSHNER

FRENCH III
COURTESY HOLLY SOLOMON GALLERY, NEW YORK

ROYAL HAWAIIAN
COLLECTION ELLEN SALTONSTALL AND ROBERT KUSHNER

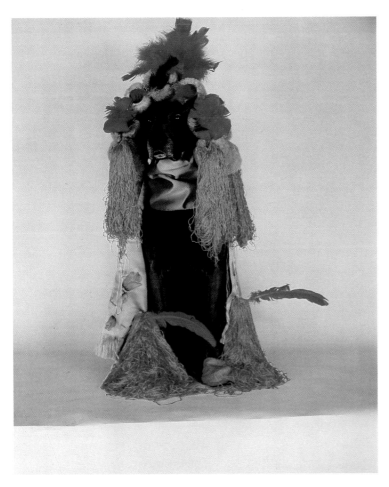 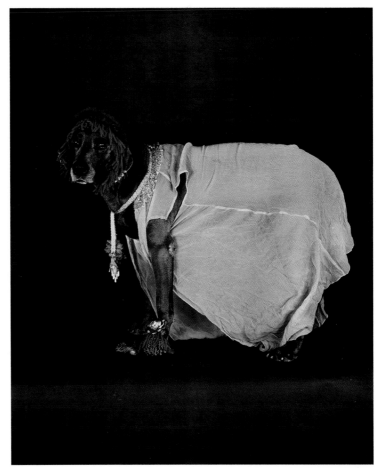

 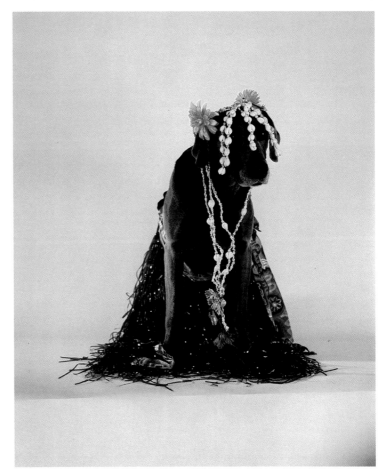

BROKEN/HURT
1981. COLLECTION WILLIAM J. HOKIN

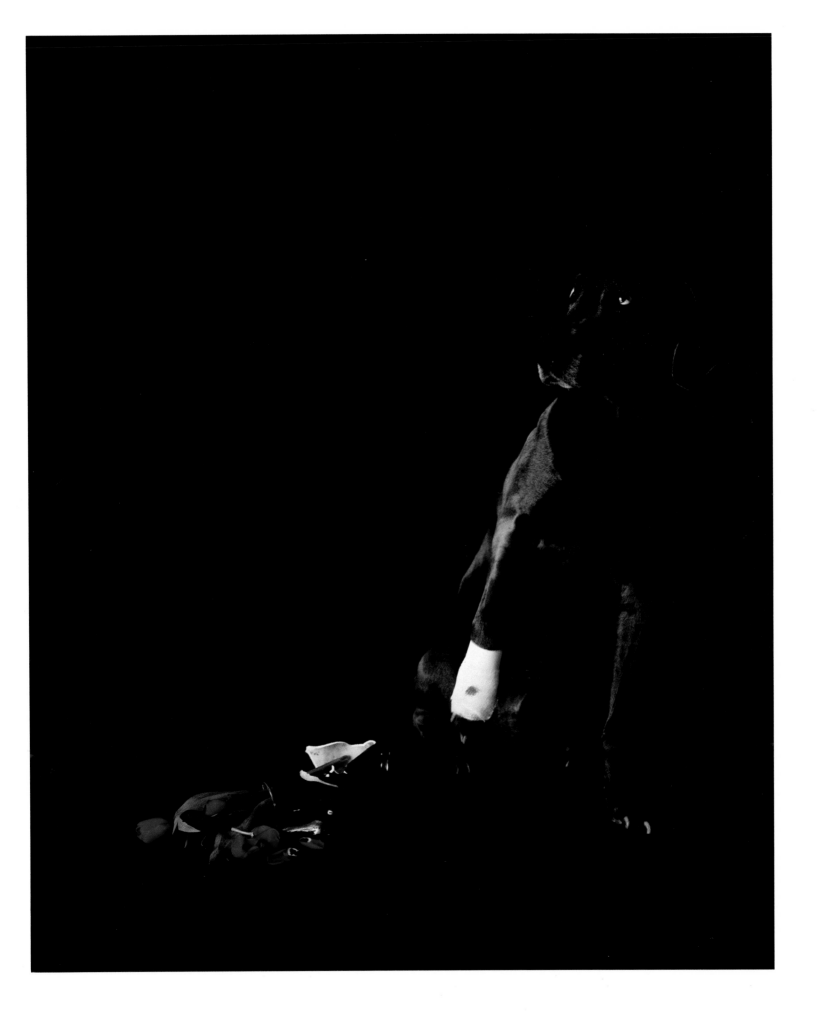

7
BAD DOG
1981. COURTESY DART GALLERY, CHICAGO, AND HOLLY SOLOMON GALLERY, NEW YORK

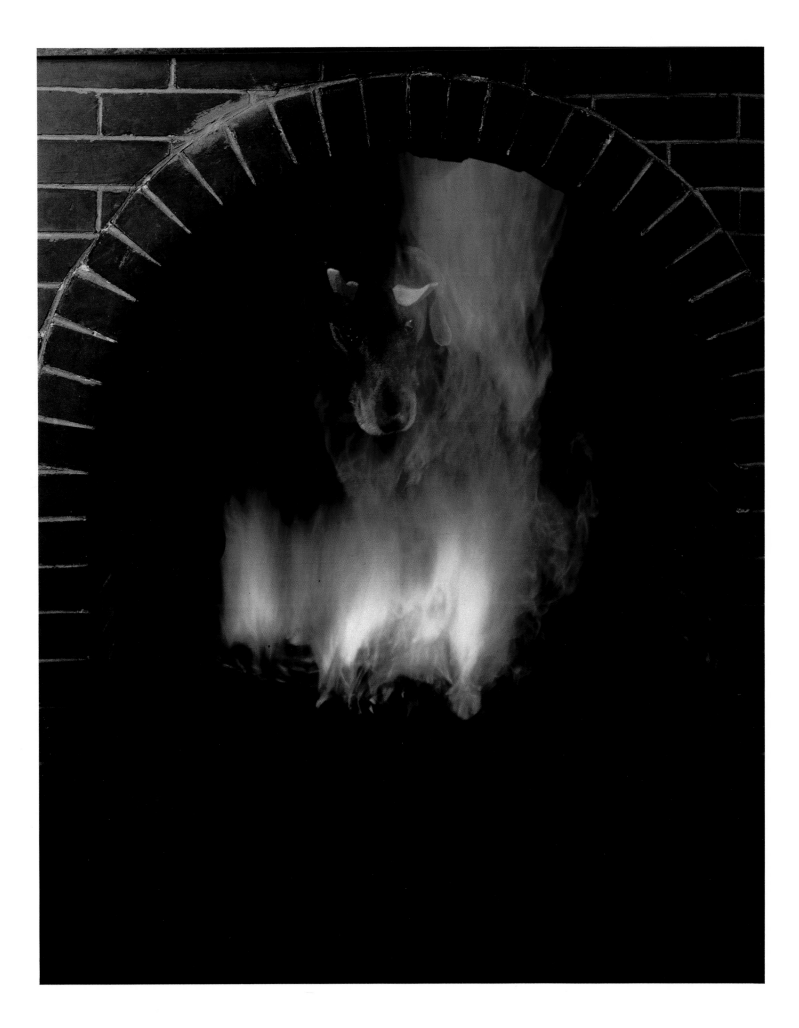

8
RAY AND MRS. LUBNER IN BED WATCHING TV (Second version)
1981. COLLECTION MR. AND MRS. THOMAS K. IRELAND

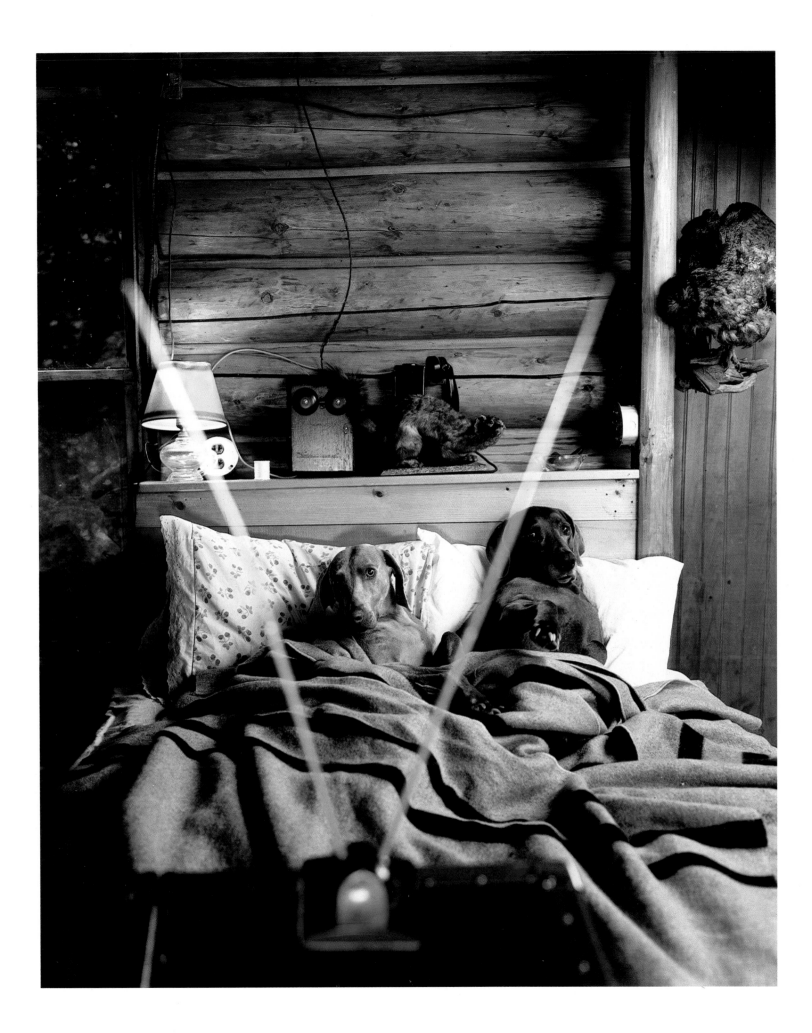

THE KENNEBAGO
1981. PRIVATE COLLECTION, NEW YORK

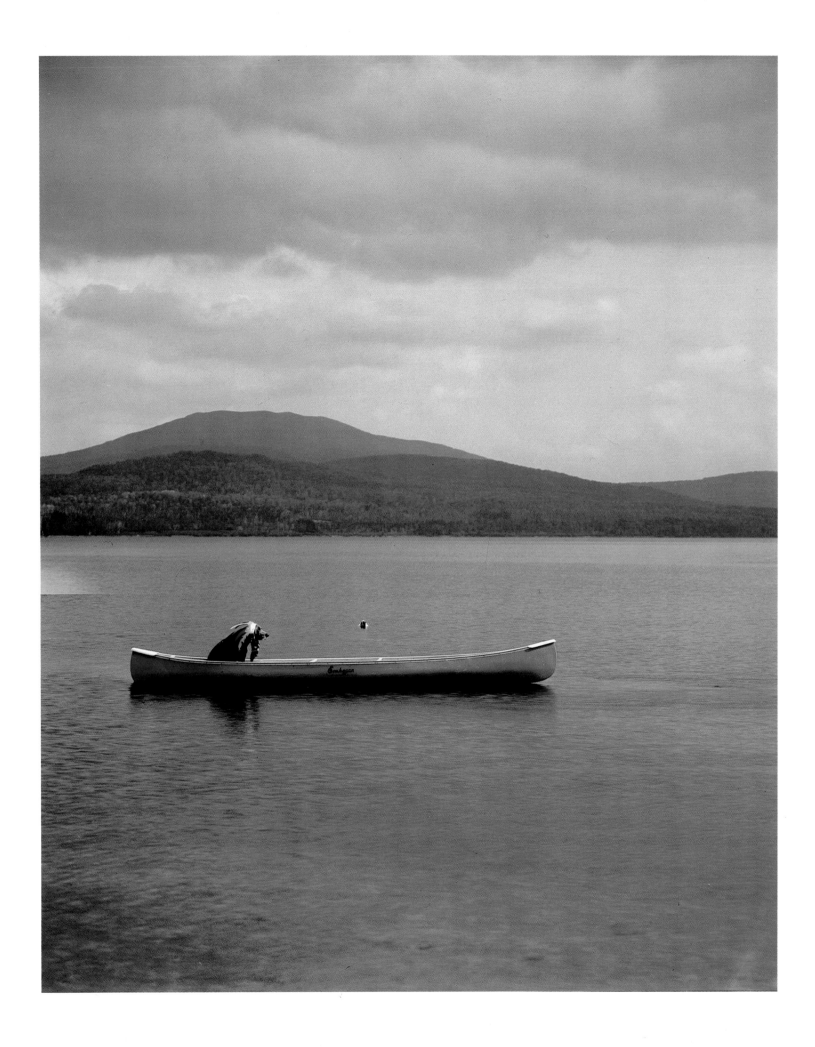

BROKEN ARROW
1980. PRIVATE COLLECTION

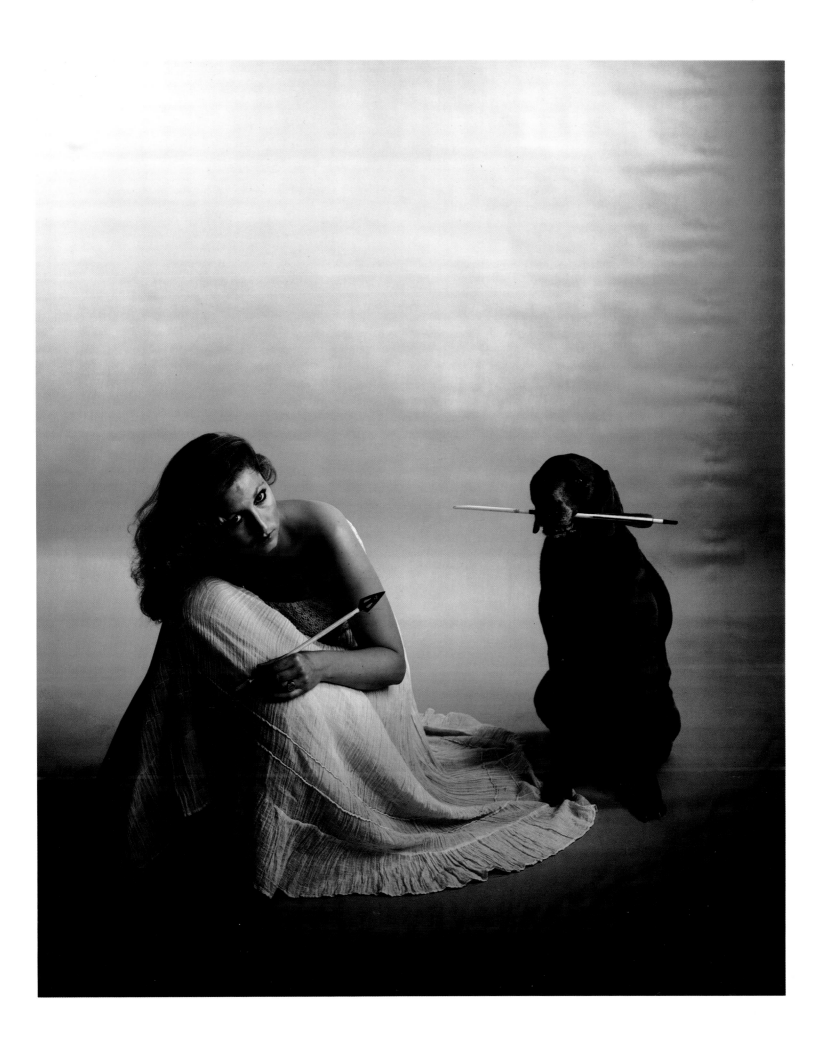

11
RAY BAT
1980. PRIVATE COLLECTION

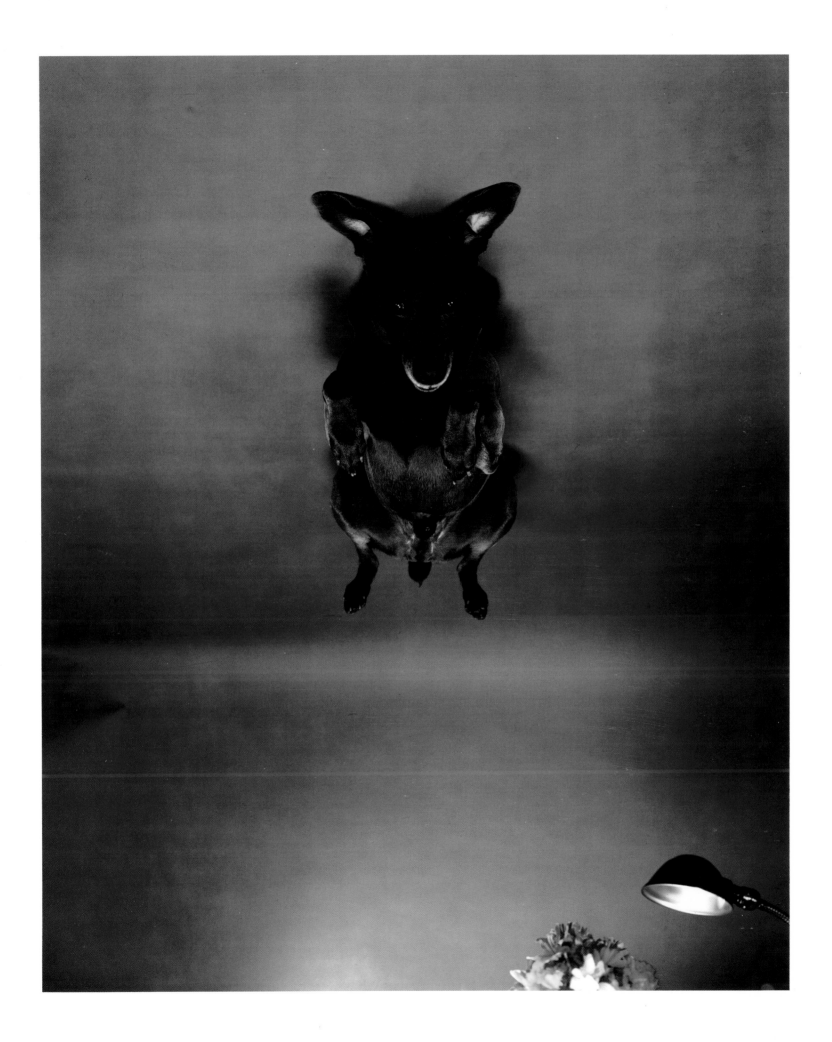

BLUE PORTRAIT
1982. COURTESY HOLLY SOLOMON GALLERY, NEW YORK

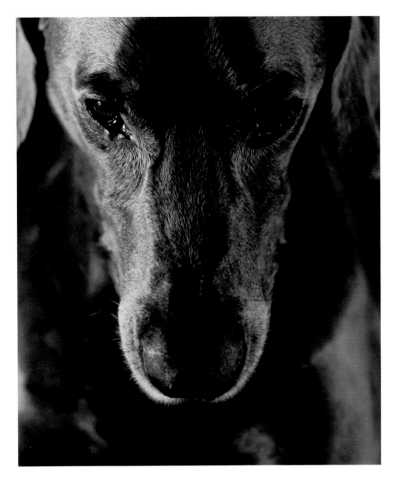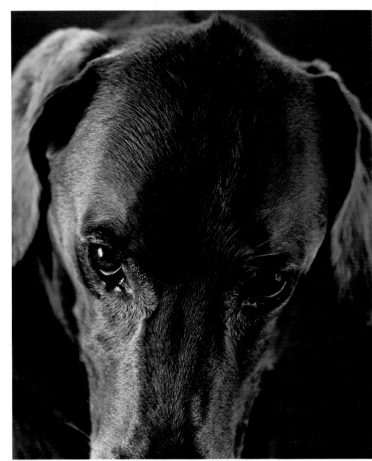

DOUBLE PROFILE
1980. UNIVERSITY GALLERY, UNIVERSITY OF MASSACHUSETTS AT AMHERST

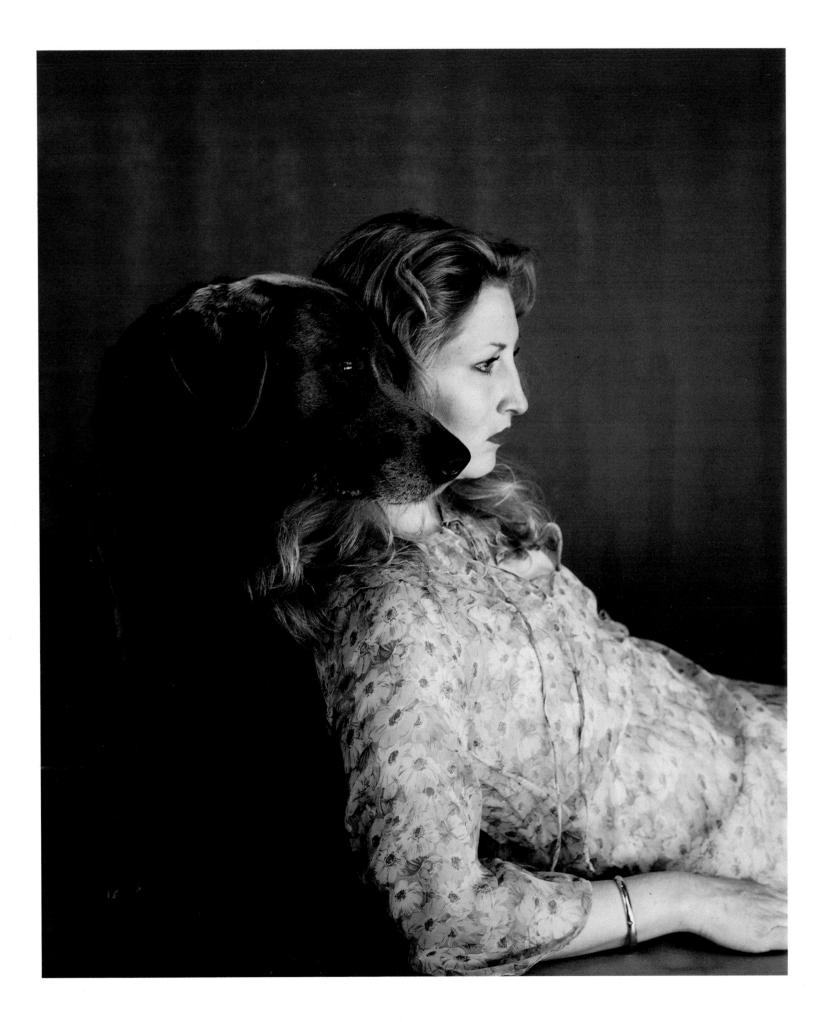

BROOKE
1980. COURTESY HOLLY SOLOMON GALLERY, NEW YORK

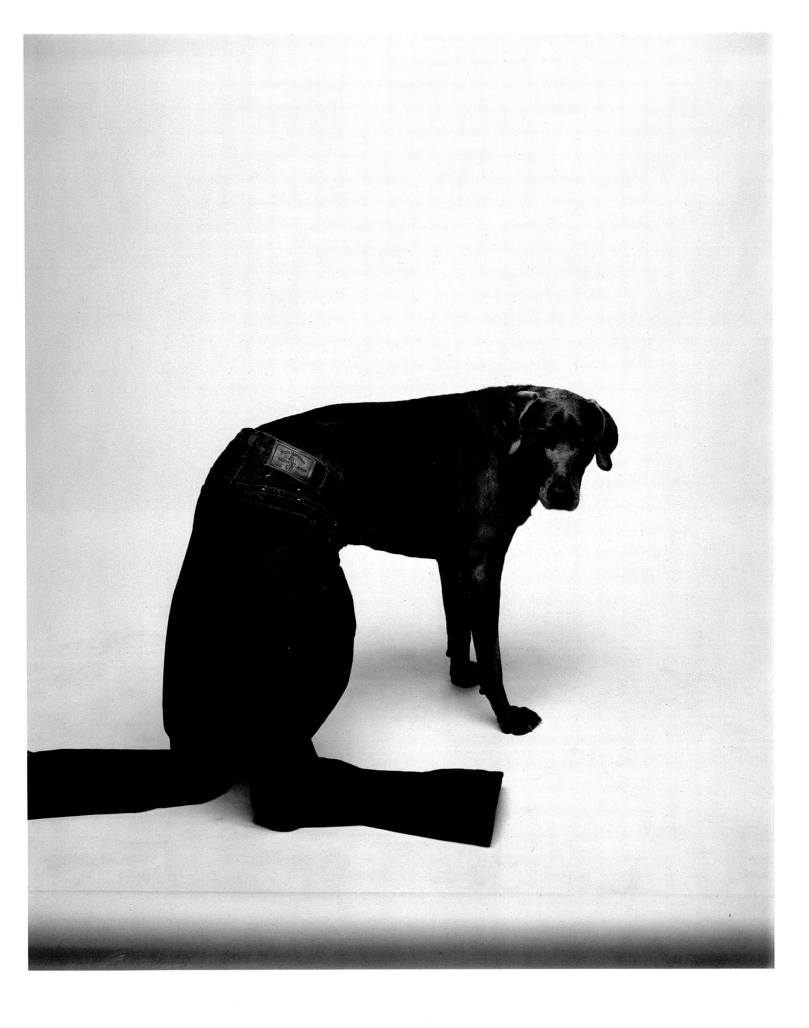

REMNANTS
1979. NEUE GALERIE, AACHEN. LUDWIG COLLECTION

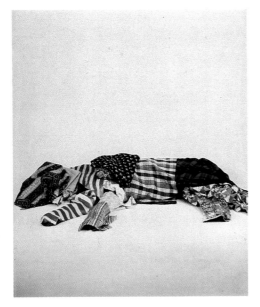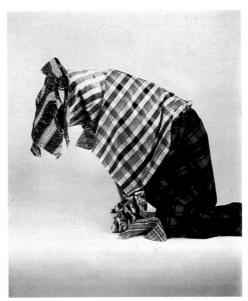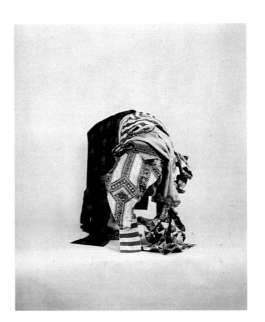

BLUE PERIOD
1981. COLLECTION ANITA GROSSMAN

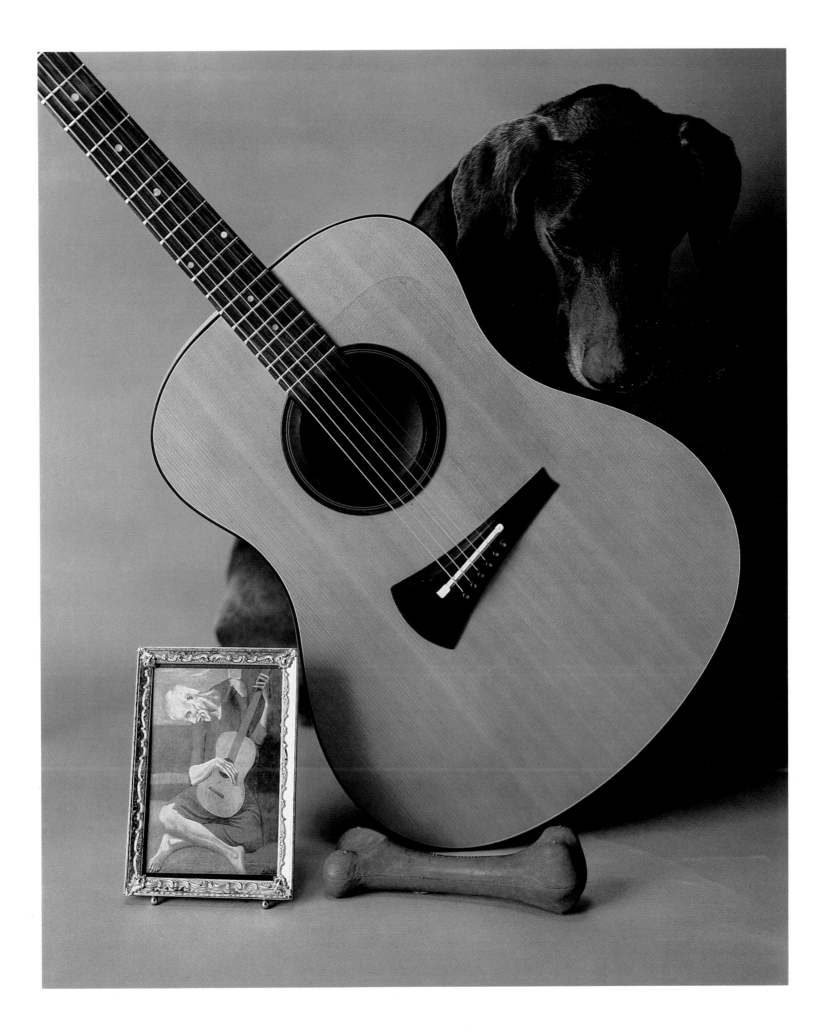

FROG/frog II
1982. COURTESY HOLLY SOLOMON GALLERY, NEW YORK

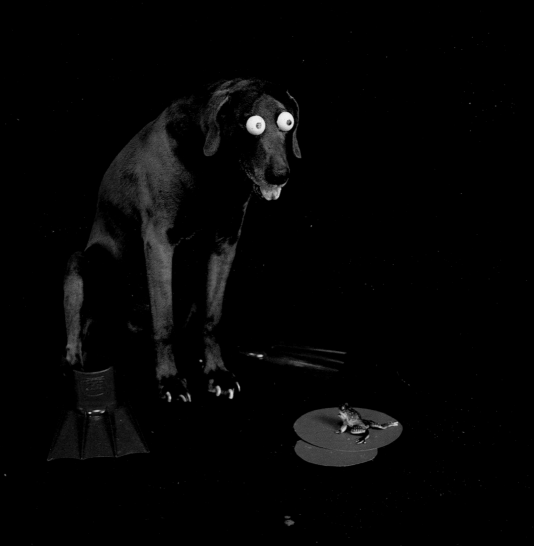

18
ALMOST 4:15
1982. COURTESY HOLLY SOLOMON GALLERY, NEW YORK

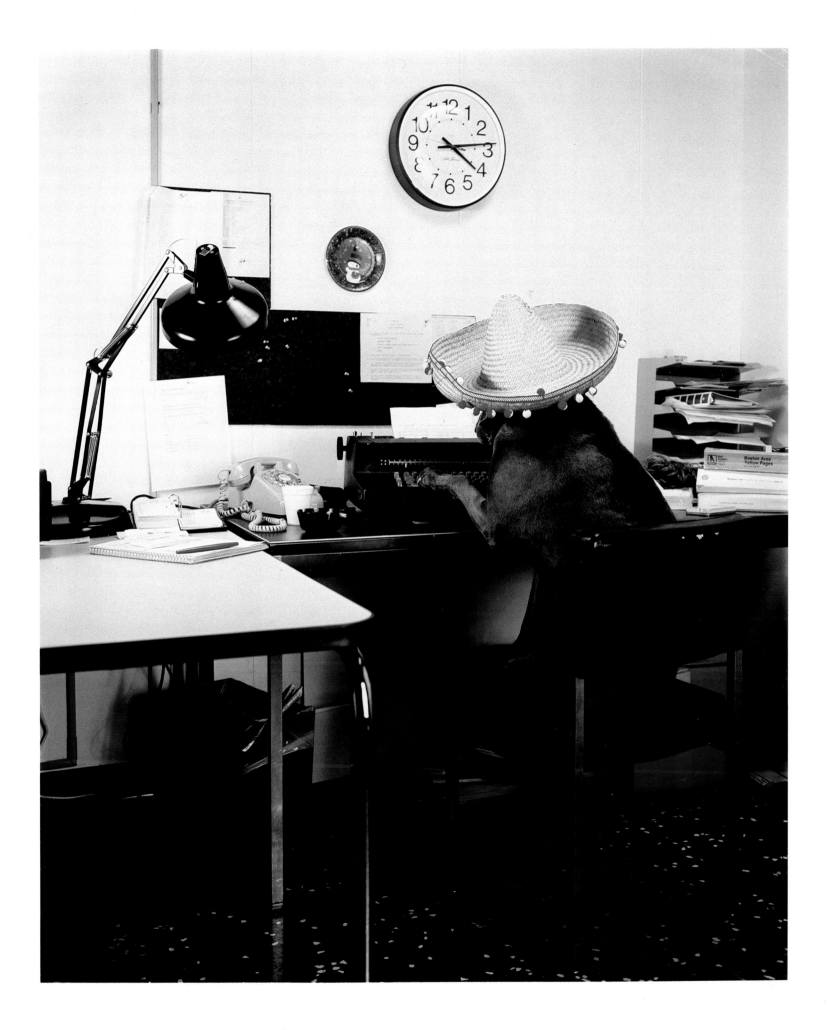

ACTOR'S NIGHTMARE
1981. COURTESY DART GALLERY, CHICAGO, AND HOLLY SOLOMON GALLERY, NEW YORK

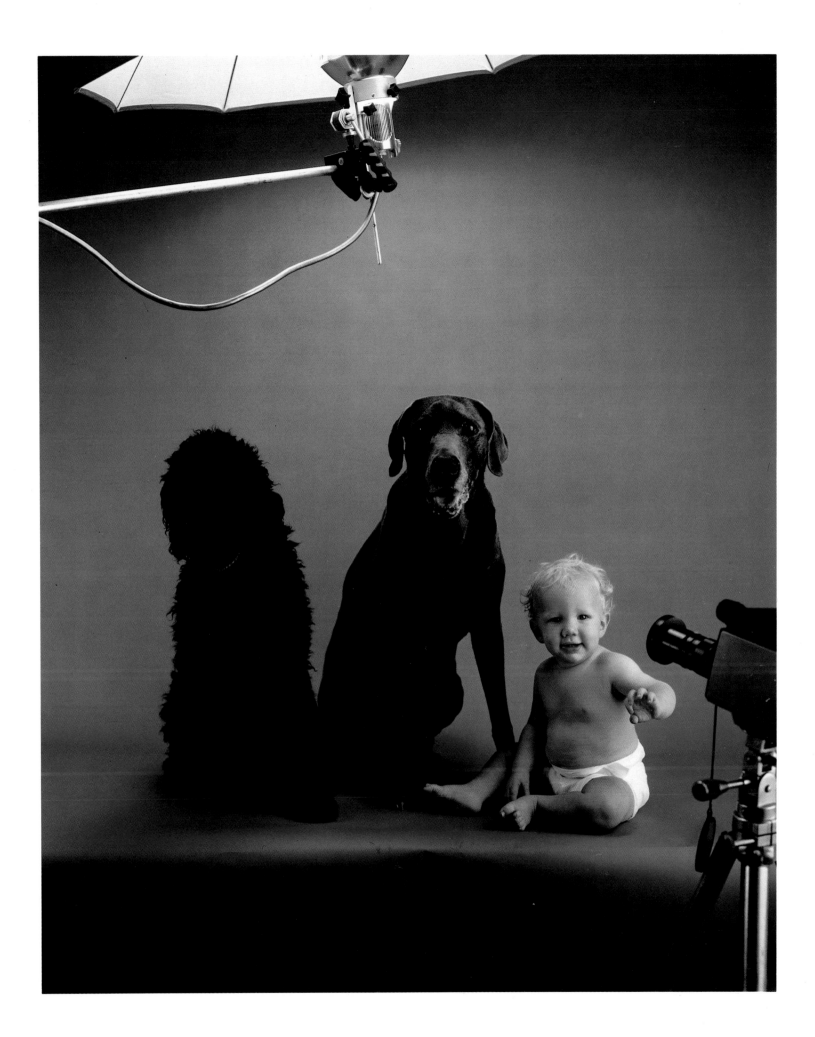

20
LEOPARD/ZEBRA—ZEBRA/LEOPARD
1981. COLLECTION SHERRY AND ALAN KOPPEL

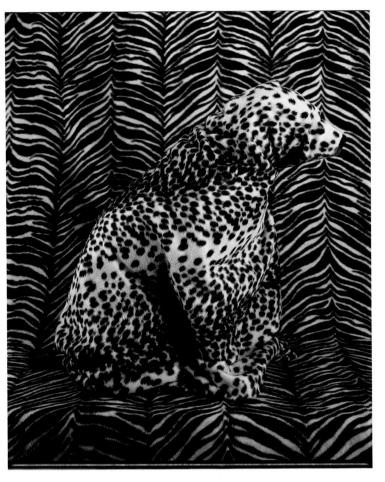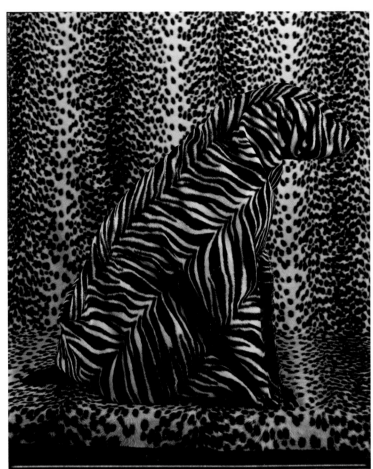

AIREDALE #I STANDING
1981. COLLECTION HOLLY AND HORACE SOLOMON

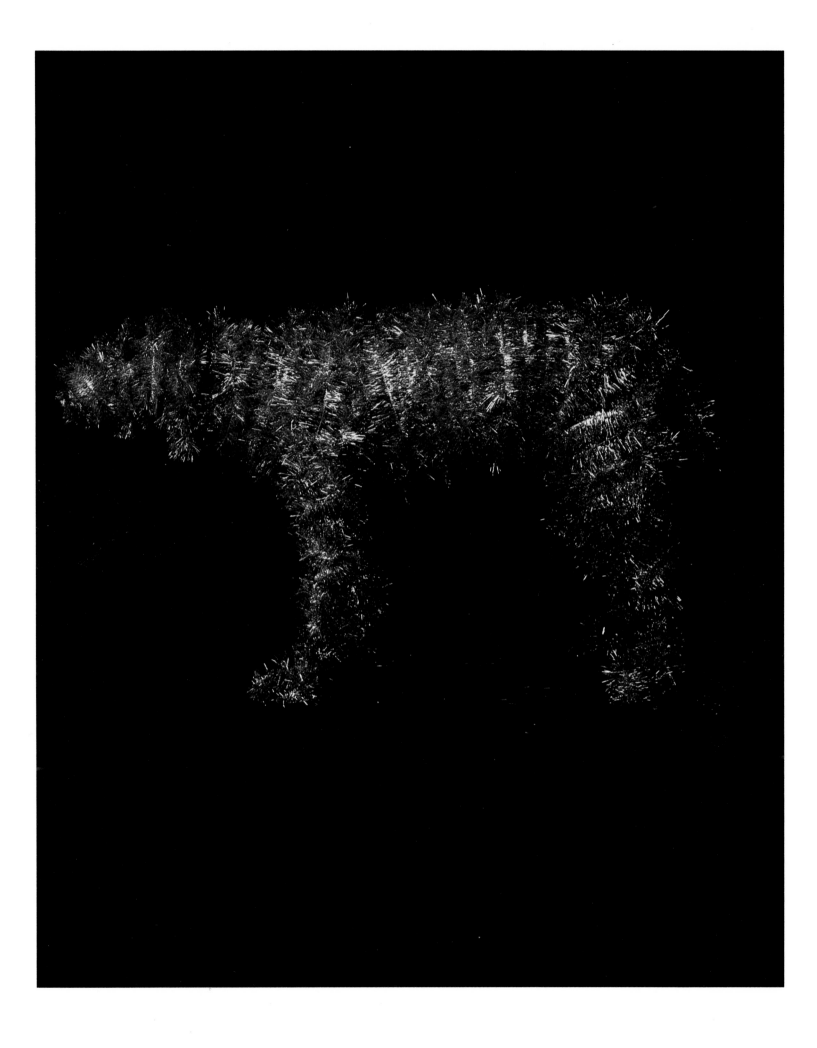

GARDEN
1982. COURTESY McINTOSH/DRYSDALE GALLERY, WASHINGTON, D.C.,
AND HOLLY SOLOMON GALLERY, NEW YORK

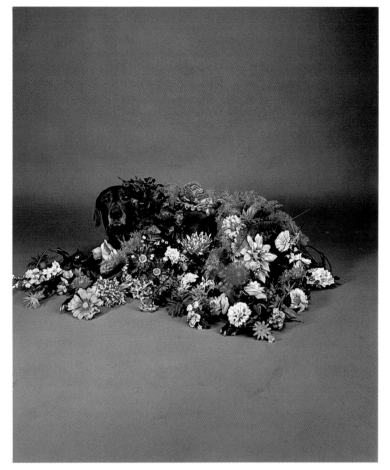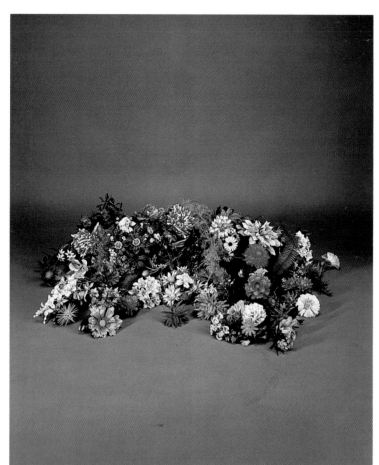

23
BABY MAGIC
1980. ART GALLERY OF ONTARIO, TORONTO

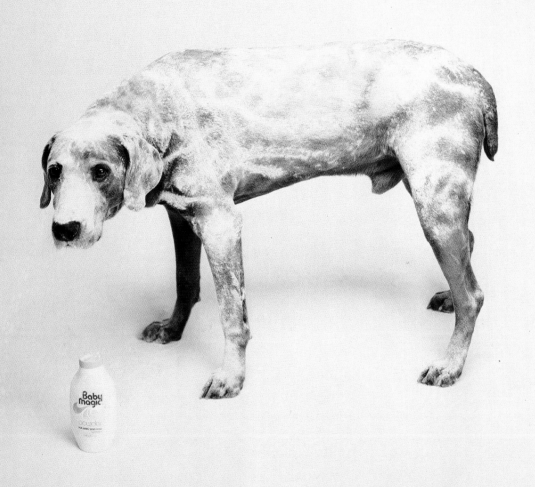

DUSTED
1982. COURTESY McINTOSH/DRYSDALE GALLERY, WASHINGTON, D.C.,
AND HOLLY SOLOMON GALLERY, NEW YORK

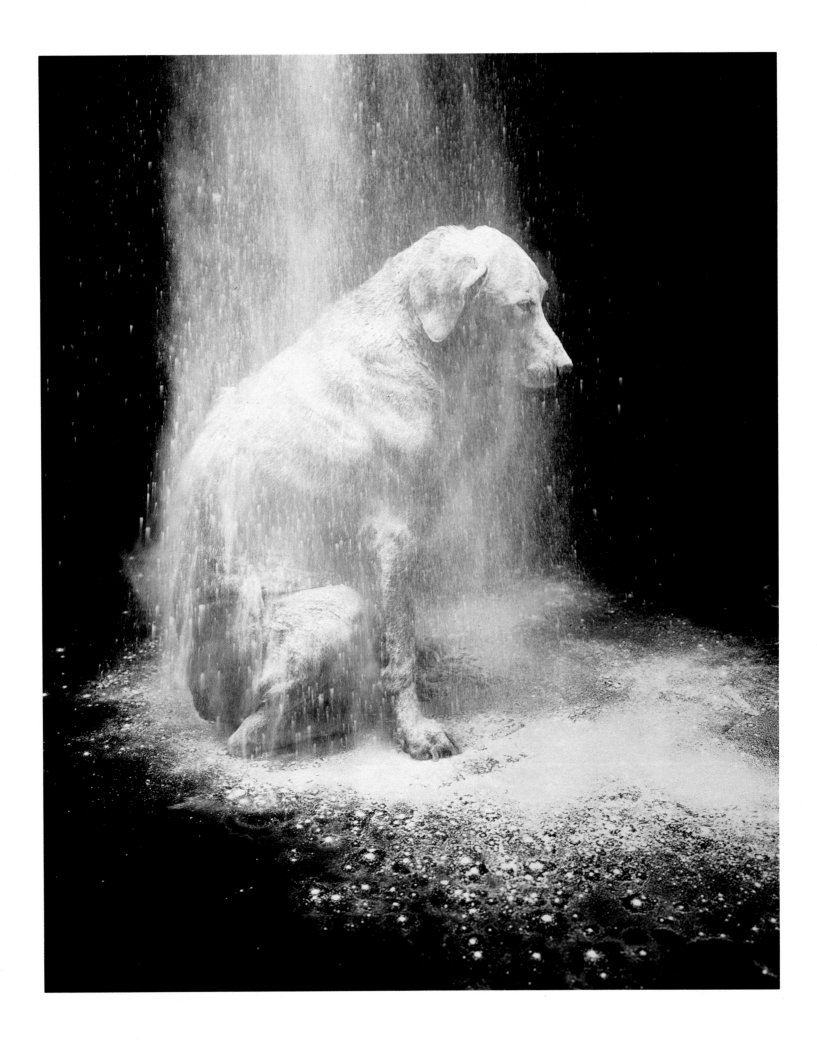

LIST OF EXHIBITIONS

SELECTED ONE–MAN EXHIBITIONS

1971
Galerie Sonnabend, Paris
Pomona College Art Gallery, Pomona, California

1972
Sonnabend Gallery, New York
Galerie Ernst, Hanover
Konrad Fischer Gallery, Düsseldorf

1973
Los Angeles County Museum of Art
Galerie Sonnabend, Paris
Texas Gallery, Houston
Konrad Fischer Gallery, Düsseldorf

1974
Modern Art Agency, Naples
Gallery D, Brussels
Galleria Toselli, Milan
Texas Gallery, Houston

1975
Galleria Alessandra Castelli, Milan
Konrad Fischer Gallery, Düsseldorf

1976
The Kitchen, New York

1977
Bruna Soletti, Milan

1978
Rosamund Felsen Gallery, Los Angeles
University Art Museum, Berkeley, California

1979
Holly Solomon Gallery, New York
Arnolfini Gallery, Bristol, England
Konrad Fischer Gallery, Düsseldorf
Otis Institute of Parsons School of Design, Los Angeles
(traveled to University of Colorado Art Gallery, Boulder,
and Aspen Center for Visual Arts, Aspen, Colorado)
University of Wisconsin–Milwaukee Fine Arts Galleries

1980
Marianne Deson Gallery, Chicago
Holly Solomon Gallery, New York

1981
Galerie Vivianne Esders, Paris
Magnuson Lee Gallery, Boston
Clarence Kennedy Gallery, Cambridge, Massachusetts
Yarlow/Salzman Gallery, Toronto
Castelli-Goodman-Solomon, East Hampton, New York

1982
Dart Gallery, Chicago
McIntosh/Drysdale Gallery, Washington, D.C.
Bruna Soletti, Milan
Fraenkel Gallery, San Francisco
Walker Art Center, Minneapolis
(traveled to Fort Worth Art Museum, Texas;
Contemporary Arts Center, Cincinnati; Corcoran Gallery of Art,
Washington, D.C.; Newport Harbor Art Museum, Newport Beach,
California; De Cordova Museum, Lincoln, Massachusetts)

SELECTED GROUP EXHIBITIONS

1971
"11 Los Angeles Artists," Hayward Gallery, London

1972
"Documenta 5," Kassel, West Germany
"Spoleto Festival," Spoleto, Italy

1973
"Festival d'Automne à Paris," Paris
"Some Recent American Art," National Gallery of Victoria,
Melbourne (traveling show)
"Whitney Annual," The Whitney Museum of American Art, New York

1975
"Dessins Contemporains," Maison de la Culture, Rennes, France
George Eastman House, Rochester, New York
"Matrix 9," Wadsworth Atheneum, Hartford, Connecticut
Städtisches Museum Leverkusen, West Germany

1976
"Commissioned Video Works," University Art Museum,
Berkeley, California
"Video Art: An Overview," San Francisco Museum of Modern Art

1977
"Photography as an Art Form," John and Mable Ringling Museum of
Art, Sarasota, Florida

1978
"Born in Boston," De Cordova Museum, Lincoln, Massachusetts
"Contemporary American Photo Works," The Museum of Fine Arts,
Houston, and Museum of Contemporary Art, Chicago

"Robert Cumming—William Wegman," Baxter Art Gallery,
California Institute of Technology, Pasadena
"23 Photographers," Walker Art Gallery, Liverpool, England

1979
"The Altered Photograph," Institute for Art and Urban Resources
at P.S. 1, Long Island City, New York
"Attitudes: Photography in the 1970's,"
Santa Barbara Museum of Art, California
"Five Artists/First Precinct," Old Slip, New York
"20x24," Light Gallery, New York

1980
"Around Picasso," The Museum of Modern Art, New York,
Penthouse Exhibition
"Artist and Camera," Arts Council of Great Britain Traveling Exhibition
"Beyond Object," Aspen Center for Visual Arts, Aspen, Colorado
"Ils se disent peintres, ils se disent photographes," Musée
d'Art Moderne de la Ville de Paris
Kröller-Müller National Museum, Otterlo, The Netherlands
"Les Nouveaux Fauves/Die Neuen Wilden," Neue Galerie,
Aachen, West Germany
"Pier and Ocean," Hayward Gallery, London

1981
"Artist's Photographs," SVC/Fine Arts Gallery,
University of South Florida, Tampa
"Instant Photography," Stedelijk Museum, Amsterdam
"Lichtbildnisse—Das Porträt in der Fotografie," Rheinisches
Landesmuseum Bonn, West Germany
"Not Just for Laughs: The Art of Subversion," The New Museum,
New York
"The Whitney Biennial," The Whitney Museum of American Art,
New York

1982
"The Biennale of Sydney," Sydney, Australia
"The Decade," Stedelijk Museum, Amsterdam
"A History of Photography from Chicago Collections,"
The Art Institute of Chicago
"Momentbild: Künstlerphotographie," Kestner-Gesellschaft,
Hanover, West Germany

VIDEOTAPES

Seven Reels, 1970–77
Gray Hairs, 1975
Man Ray, Man Ray, 1979
Videotapes at Castelli-Sonnabend Tapes and Films, Inc., New York

PHOTOGRAPH CREDITS

All black-and-white photographs courtesy William Wegman.
William Wegman's color photographs are all one-of-a-kind
20-x-24-inch Polaroids, made on Polacolor II and Polacolor ER film.
We would like to thank the following sources for the photographs
of the Polaroids reproduced in this book:
Camera Arts magazine, New York: plates 6, 23; D. James Dee, New York:
plates 1, 4, 5, 8, 9, 10, 11, 12, 15, 17, 18, 20, 21, 22, 24; Holly
Solomon Gallery, New York: plate 3;
Uli Koecher/Kestner-Gesellschaft, Hanover, West Germany:
plates 14, 16; Michael Tropea, Chicago: plates 2, 7, 19;
University of Massachusetts at Amherst: plate 13.